Matignon High School Library
232.96 NOU

MHS00000003694
Walk with Jesus :

WALK WITH JESUS

Henri Nouwen

WALK WITH JESUS

Stations of the Cross

Illustrations by Sister Helen David

MATIGNON HIGH SCHOOL LIBRARY

ORBIS BOOKS

Maryknoll, New York 10545

232.96

Nou

11268

Second Printing, February 1990

The Catholic Foreign Mission Society of America (Maryknoll) recruits and trains people for overseas missionary service. Through Orbis Books, Maryknoll aims to foster the international dialogue that is essential to mission. The books published, however, reflect the opinions of their authors and are not meant to represent the official position of the society.

For the text of the book, copyright © 1990 by Henri Nouwen
For the illustrations, copyright © 1990 by Sr. Helen David

Published by Orbis Books, Maryknoll, NY 10545
All rights reserved
Manufactured in Hong Kong

ISBN 088344-666-9

CONTENTS

v

ACKNOWLEDGMENTS

These reflections, made in response to Sister Helen David's Stations of the Cross, were written mainly during a three-and-a-half week stay at York Central Hospital in Richmond Hill, Ontario. While hitchhiking to work in the early morning of an icy day, I was hit by the outside rear-view mirror of a passing van, broke five ribs, and had to have my spleen removed. Although, at the time, it all seemed a quite unhappy event, it was, in fact, a blessing in disguise, an occasion to stop everything I was so busy doing and to pay special attention to Jesus and my friends. Writing these reflections was one of the unexpected fruits of my time in hospital.

I am deeply grateful to Connie Ellis, my secretary, who gave me much support during these weeks and was able, among a thousand other things, to work on this text. I also owe much to Conrad Wieczorek, who offered to give priority to the editing of these reflections.

A very special word of thanks goes to Sister Helen David for asking me to write these reflections, and for her great patience after I had said yes. I also want to thank Robert Ellsberg, the editor-in-chief of Orbis Books, for his friendship and his generous cooperation in bringing together Sister Helen David's art work and my words in this handsome book.

PREFACE

The fifteen Stations of the Cross painted by Sister Helen David make us look at the passion and resurrection of Jesus with new eyes. Through a window framed by a stylized cross, we discover how Jesus continues his painful, yet hopeful journey among our brothers and sisters who are being condemned, kidnapped, starved, abandoned, tortured, and killed, day after day all over the world. Through this same window, we are also able to see expressions of trust, hope, and love in the midst of the darkness. I have looked long and intensely at these paintings and have come to realize, more and more, that the suffering as well as the joy that we witness in so many countries today are nothing less than the ongoing revelation of the unfathomable mystery of Good Friday, Holy Saturday, and Easter Sunday.

"When I am being lifted up from the earth," Jesus said, "I shall draw all people to myself" (John 12:32). People from all times and all places have been drawn into the suffering and risen body of Jesus. There is, indeed, no human pain or human joy that Jesus has not taken into himself. And because of this we are enabled to see our world through the window of the cross, to face the terrible reality of human sorrow while not giving in to despair.

It has been a real grace for me to reflect on Sister Helen David's Stations. What most moved me was that these Stations were created not to make us feel guilty about human suffering far away from us, but to help us

unite our own broken humanity with the humanity of the men, women, and children portrayed in these paintings. This union becomes possible through the suffering and risen body of Jesus. In and through Jesus, our world can become one because in his divine love he embraces all of us and desires that we all will be one as he and his Father are one (see John 17:21).

I have written these meditations with my eyes on Jesus who wants to break down the walls between the Third World and ourselves, the poor and the rich, the healthy and the sick, those far away and those close by, those who suffer in their bodies and those who suffer in their innermost being. In the heart of Jesus there is no place for anxious comparisons between the degrees and depths of human suffering. Little is accomplished by wondering who suffers more than who, and whose pain is the worst. Jesus died and rose for all people, with all their differences, so that all could be lifted up with him into the splendor of God.

There is immense pain in the wide world around us; there is immense pain in the small world within us. But all pain belongs to Jesus and is transformed by him into glorified wounds which allow us to recognize him as our risen Lord.

I pray that all those who may see and read this book will enter ever more fully, through the passion and resurrection of Jesus, into the presence of God and that of all our brothers and sisters everywhere in the world.

WALK WITH JESUS

Introduction

I WALK
WITH JESUS

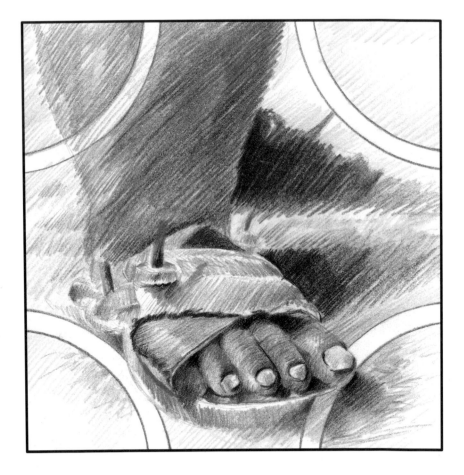

Whenever I think about the poor, the image that comes to me is that of men and women walking on the side of the road with heavy burdens on their backs. I remember seeing them walking early in the morning to the marketplace or to the fields, hoping to sell something, or to buy something, to find work, or perhaps to meet someone who would give them enough to make it through another day. I remember feeling guilty sitting in a car and seeing so many people walking—sometimes barefoot, sometimes in worn-out sandals.

I saw them walking on the dusty roads of Bolivia, Peru, and Guatemala, and, with the eyes of my heart, I see them still. The poor are walking the roadsides of our world, carrying heavy burdens, trying to survive.

I haven't done much walking in my life. There have always been planes, trains, cars, and buses to take me from one place to another. My feet have not had much contact with the dust of the earth; there have always been wheels to make it easy for me. In my world there are not many people who walk. It is hard even to find anyone on the side of the road to ask for directions. In my world people go from one place to another locked in their moving cubicles, listening to a favorite cassette, and only occasionally meeting other people in parking lots, supermarkets, or fast-food outlets.

But Jesus walked, and he still does. Jesus walks from village to village, and, as he walks, he meets the poor.

He meets the beggars, the blind, the sick, the mourners, and those who have lost hope. He remains very close to the earth. He feels the heat of the day and the cold of the night. He knows about the grass that withers and fades, the rocky soil, the thorny bushes, the barren trees, the flowers in the fields, and the rich harvest. He knows because he walks so much and feels in his own body the harshness and the vitality of the seasons. He listens attentively to those with whom he walks, and he speaks to them with the authority of a true companion on the road. He is stern yet very merciful, direct yet very gentle, demanding yet very forgiving, probing yet very respectful. He cuts deep, but with the hands of a healer; he separates, but only to let grow; he repudiates, but always to make affirmation possible. Jesus is deeply connected to the earth on which he walks. He observes the forces of nature; he learns from them, teaches about them, and reveals that the God of Creation is the same God who sent him to announce good news to the poor, sight to the blind, and freedom to the prisoners.

The poor who walk on the roads and through the deserts and rough places of this world call me to humility — derived from the Latin word "humus," which means earth or soil. I have to remain close to the soil, the earth. Often I look up into the clouds and daydream about a better world. But my dreams will never bear fruit unless I keep turning my eyes again and again back to the earth and to all those people walking their long, fatiguing walks and inviting me to accompany them. But what does it mean to walk with the poor? It means to recognize my own poverty: my deep inner brokenness, my fatigue, my powerlessness, my mortality. It is there that I am connected with the earth; there that I am truly humble. Yes, it is there that I enter into solidarity with all

who walk the earth and discover that I, too, am loved as a very fragile, precious person.

Before Jesus entered into his passion, "when he knew that he had come from God and was returning to God, he took a towel, and began to wash his disciples' feet" (John 13:5). The Word became flesh so as to wash my tired feet. He touches me precisely where I touch the soil, where earth connects with my body that reaches out to heaven. He kneels and takes my feet in his hands and washes them. Then he looks up at me and, as his eyes and mine meet, he says: "Do you understand what I have done to you? If I, your Lord and Master, have washed your feet, you must wash your brothers' and sisters' feet" (John 13:13–14).

As I walk the long, painful journey toward the cross, I must pause on the way to wash my neighbors' feet. As I kneel before my brothers and sisters, wash their feet, and look into their eyes, I discover that it is because of my brothers and sisters who walk with me that I can make the journey at all.

I

JESUS IS
CONDEMNED

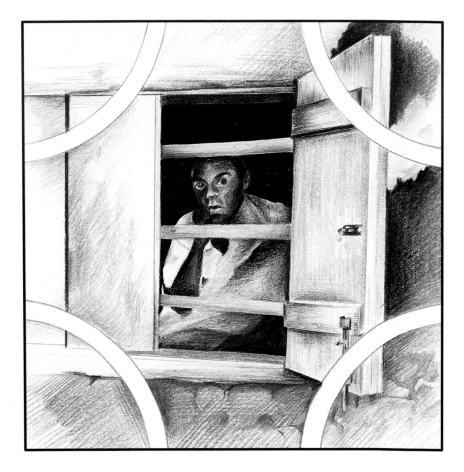

man behind bars. He is condemned to death. He is put in the category of the "damned." He is no longer considered worthy to live. He has become the enemy, the rebel, the outsider, a danger to society. He has to be put away, cut out of the communal life.

Why? Because he is different. He is black, and blacks are dangerous. He is gay, and gays are perverts. He is a Jew, and Jews cannot be trusted. He is a refugee, and refugees are threats to our economy. He is an outsider, saying what we do not want to hear, and reminding us of what we would rather forget. He upsets our well-ordered lives. He tears aside the veil that covers our impurities and breaks down the walls that keep us safely separated. He says, "We belong to the same humanity, we are all children of the same God; we are all loved as God's favorite sons and daughters; we are all destined to live in the same home, with the same father, and eating together at the same table." He says, "Apartheid is not according to God's plan. Unity and communion are."

That voice has got to be silenced. It upsets the way we do things here. It disturbs our family life, our social life, our business life. It creates disorder, yes, even chaos. Life is complex enough as it is. We do not need prophets who destroy the delicate web of relationships we have so carefully worked out. Let us stick to the motto: Everyone for himself and God for us all. That way there is a minimum of pain and a maximum of comfort.

Jesus stands before Pilate. He is silent. He does not defend himself against the many charges made against

him. But when Pilate asks him, "What have you done?" he says, "I came into the world for this, to bear witness to the truth; and all who are on the side of truth listen to my voice" (John 18:35–38). The truth of which Jesus speaks is not a thesis, or a doctrine, or an intellectual explanation of reality. It is the very relationship, the life-giving intimacy between himself and the Father of which he wants us to partake. Pilate could not hear that, nor can anyone who is not connected to Jesus. Anyone, however, who enters into communion with Jesus will receive the Spirit of truth—the Spirit who frees us from the compulsions and obsessions of our contemporary society, who makes us belong to God's own inner life, and allows us to live in the world with open hearts and attentive minds. In communion with Jesus, we can hear the Spirit's voice and journey far and wide, whether we are in prison or not. Because the truth—the true relationship, the true belonging—gives us the freedom that the powers of darkness cannot take away. Jesus is the freest human being who ever lived because he was the most connected to God. Pilate condemned him. Pilate wanted to make him one of the damned. But he could not. Jesus' death, instead of being the execution of a death sentence, became the way to the full truth, leading to full freedom.

I know that the more I belong to God, the more I will be condemned. But the condemnation of the world will reveal the truth. "Blessed are those who are persecuted in the cause of uprightness, the kingdom of heaven is theirs" (Matt. 5:10). I have to trust these words. Precisely there where the world hates me, where I am not taken seriously by the powers that be, where I am pushed aside, laughed at and made marginal, there precisely I may discover that I am part of a worldwide community

that is barred, fenced in, and locked away in isolated camps.

I hunger for the truth, for that communion with God that Jesus lived. But every time that hunger is satisfied, I will be condemned again and given a heavy cross to bear. It is the story of Peter and John, Paul and Barnabas, James and Andrew, and most of all of Mary, the mother of Jesus. Their joy and sorrow became one because they chose to live the truth in the world. That cannot happen without our being given a cross to bear, but also not without the immense joy of being already now part of the divine life that reaches beyond any barred fence or gallows.

Yes, there is fear in the eyes of the man behind the bars, but also conviction, trust, hope, and a deep knowledge of freedom. His eyes and mine are eyes that see what the world cannot see: the face of a suffering God who calls us far, far beyond our fears into the land of a love that lasts.

II

JESUS CARRIES HIS CROSS

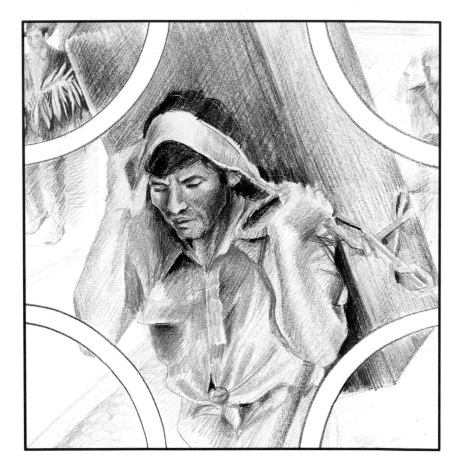

A young Guatemalan carries a heavy load of wood. The wood is for coffins to bury the Indian men who have been kidnapped, murdered, and found dead on the side of the road, or to bury the children who could not survive the diseases that touched them as soon as they were born. It happened many years ago when the international press reported it with great indignation. It happens still today when the subject is no longer newsworthy and remains hidden from the eyes of the world.

Young men are murdered with guns, knives, and electric prods. Small children die from malnutrition, dehydration, and lack of care. Day after day, violence and poverty bring death to the little villages of Guatemala, Bolivia, Peru, Ethiopia, the Sudan, Bangladesh, and countless other countries.

I am haunted by the face of the young Indian with the heavy burden on his head and shoulders. His eyes are almost shut, his brow furrowed by deep sorrow, his face already old. Death is very close to him, and still there is such dignity, such serenity, such deep knowledge of who he is. His mouth does not utter many words; his heart is silent. His bony body has already lived more than I ever will, even though I may reach old age. He carries the cross of humanity: "a man of sorrow, familiar with suffering" (Isa. 53:3). He knows that soon a car may stop, armed men may bind him and drag him off to be cruelly tortured and thrown naked into the street. He knows it, but he keeps walking, carrying the wood for the coffins of his friends.

Pilate handed Jesus over to be scourged. The soldiers "stripped him and put a scarlet cloak around him, and having twisted thorns into a crown, they put this on his head and placed a reed in his right hand. To make fun of him they knelt to him saying: 'Hail, King of the Jews!' And they spat on him and took the reed and struck him on the head with it. And when they had finished making fun of him, they took off the cloak and dressed him in his own clothes and led him away to crucifixion" (Matt. 27:28–31). Jesus undergoes it all. The time of action is past. He does not speak any more; he does not protest; he does not reproach or admonish. He has become a victim. He no longer acts, but is acted upon. He has entered his passion. He knows that most of human life is passion. People are being starved, kidnapped, tortured, and murdered. People are being imprisoned, driven from their homes, separated from their families, put into camps, and used for slave labor. They do not know why. They do not understand the cause for it all. Nobody explains. They are poor. When Jesus felt the cross put on his shoulders, he felt the pain of all future generations pressing on him; he saw the young Guatemalan man and loved him with an immense compassion.

I feel very powerless. I want to do something. I have to do something. I have, at least, to speak out against the violence and malnutrition, the oppression and exploitation. Beyond this, I have to act in any way possible to alleviate the pain I see. But there is an even harder task: to carry my own cross, the cross of loneliness and isolation, the cross of the rejections I experience, the cross of my depression and inner anguish. As long as I agonize over the pain of others far away but cannot carry the pain that is uniquely mine, I may become an activist, even a defender of humanity, but not yet a follower of

Jesus. Somehow my bond with those who suffer oppression is made real through my willingness to suffer my loneliness. It is a burden I try to avoid, sometimes, by worrying about others. But Jesus says: "Come to me, all you who labor and are overburdened, and I will give you rest" (Matt. 11:28). I might think that there is an unbridgeable gap between myself and the Guatemalan wood carrier. But Jesus carried his cross for both of us. We belong together. We must each take up our own cross and follow him, and so discover that we are truly brothers who learn from him who is humble and gentle of heart. In this way only can a new humanity be born.

III

JESUS FALLS
FOR THE FIRST
TIME

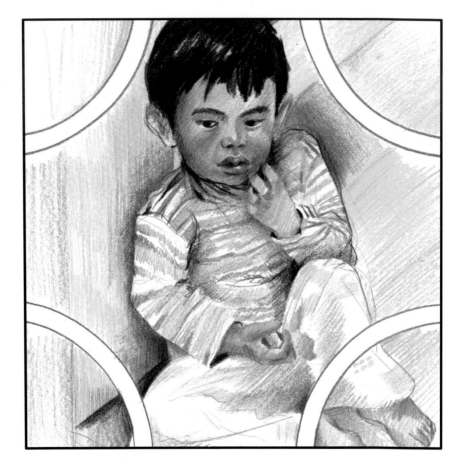

This little Vietnamese boy is left behind. Why? Maybe his parents were killed, abducted, or put in camps. Maybe they tried to escape from the enemy and got caught in an ambush. Maybe they were boat people who drowned. Maybe, maybe . . . but their child is left alone. As I look into these eyes gazing into an empty future, I see the eyes of millions of children crushed by the powers of darkness. This small, tender child needs to be held, needs to be hugged, kissed, cuddled. He needs to feel the strong, loving hands of his father, hear the tender words of his mother, and see the eyes of those who say: "How beautiful you are." Where will this boy be safe? Where will he know that he is truly loved? Where can he run to when he gets scared and confused? Where can he let his tears flow freely, his pain be received, his fearful dream be dispelled? Who tickles his feet? Who squeezes his hand? Who rubs his cheeks? He sits there, vulnerable, lonely, forgotten. He is left behind by a humanity that can no longer hold on to its future.

All over the world, children fall under the weight of violence, war, corruption, and human anguish. They are hungry, hungry for affection and food. In the cold halls of institutions, they sit . . . waiting for someone to pay attention. They sleep with strangers who use them to satisfy their own desires. They roam the streets of the big cities, trying to survive alone or in small bands. There are thousands, yes, millions of them all over the world. They have not heard the voice that says: "You are my beloved, on you my favor rests" (Luke 3:22).

Nowhere is our fallen humanity so painfully set before us as in these children. They reveal our sins to us. Abandoned and alone, they tell us that we have lost the grace to love our own.

What will become of these children when they grow older and become the men and women of the future. Will they grab the gun in a desperate search for revenge? Will they withdraw into lifelong silence in the wards of mental hospitals, or be locked behind bars as dangerous criminals? Will they become terrorists, gangleaders, drug smugglers, pimps, or prostitutes? Or will they discover that beyond and behind all human manipulations there are hands that hold them safe and offer a love that has no conditions?

Jesus fell under his cross. He continues to fall. Jesus is not the conquering hero who undergoes suffering with staunch determination and an iron will. No, he who was born as a child of God and a child of Mary, adored by shepherds and wise men, never became the proud self-possessed leader who wanted to lead humanity to the great victory over the powers of darkness. When he had grown into maturity, he humbled himself by joining penitent men and women and receiving baptism in the river Jordan. It was then that he heard that voice deeply entering his heart: "This is my Son, the Beloved, my favor rests on Him" (Matt. 3:17). That voice carried him through life and shielded him from bitterness, jealousy, resentment, and revenge. He always remained a child and said to his followers: "Unless you change and become like little children, you will never enter the kingdom of heaven" (Matt. 18:3). Jesus is the innocent child falling under the heavy burden of the cross of human anguish—powerless, weak, and very vulnerable. But there we can touch the mystery of the compas-

sionate heart of God that embraces all children, around as well as within us.

I know that I am a child, a child who, underneath all my accomplishments and successes, keeps crying out to be held safe and loved without conditions. I also know that losing touch with my child is losing touch with Jesus and all who belong to him. Each time I touch my own child, I touch my powerlessness and my fear of being left alone with no one to give me a safe place. Jesus falls beneath the cross to allow me to reclaim my child, that place in me where I am out of control and in desperate need of being lifted up and reassured. The abandoned children of the world are in me. Jesus tells me not to be afraid, to face them in my heart and suffer with them. He wants me to discover that beyond all emotions of rejection and abandonment there is love, real love, lasting love, love that comes from a God who became flesh and who will never leave his children alone.

IV

JESUS MEETS MARY

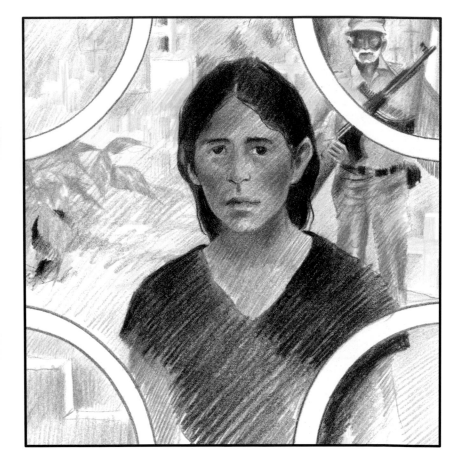

This Nicaraguan woman who lost her son in the war is filled with deep sorrow, but she does not faint. She looks me straight in the eyes with an immense confidence that there is victory beyond death.

I vividly remember meeting the mothers of slain Nicaraguan farmers in Jalapa, a small town close to the Honduran border. I was with a group of North Americans who felt co-responsible for the war whose victims these farmers had become. One of us asked them, "Can you forgive us for the violence you and your family have suffered?" There was a long silence . . . but then one of the women said with a strong voice, "Yes, we forgive you," and the others repeated her words, "Yes, we forgive you." Another one of us said, "But can you also forgive us for the years of suffering and anguish caused by the economic boycott our country imposed on you?" Again there was the answer, "Yes, we forgive you." Still another voice was raised, "What about all the years in which we treated you as our backyard and exploited you for cheap labor and cheap fruit?" The answer was the same, even stronger, "Yes, we forgive you, and we want you to work with us for a better world so that the deaths of our children will not prove useless." As I heard this litany of guilt and forgiveness and looked into the eyes of these women of faith, I realized that these women represented thousands of women all over the world who keep offering peace instead of war, hope instead of despair, forgiveness instead of revenge. They are the

women of Leningrad, Belfast, Teheran, and countless other cities and villages whose sorrow for their dying children becomes the fertile ground of compassion and healing.

Jesus met his mother as he was being led to his execution. Mary did not faint; she did not scream in rage or despair; she did not try to prevent the soldiers from torturing him more. She looked him in the eyes and knew that this was his hour. In Cana, when she had asked his help, he had put some distance between them and said: "Woman, . . . My hour has not yet come" (John 2:4). But now his sorrow and her sorrow merged in a deep knowledge of the hour in which God's plan of salvation was being fulfilled. Soon Mary will stand under the cross and Jesus will give her to John, his beloved disciple, with the words: "This is your mother" (John 19:27). Mary's sorrow has made her not only the mother of Jesus, but also the mother of all her suffering children. She stood under the cross; she stands there still and looks into the eyes of those who are tempted to respond to their pain with revenge, retaliation, or despair. Her sorrow has made her heart a heart that embraces all her children, wherever they may be, and offers them maternal consolation and comfort.

As I look at Mary and all the mothers of sorrow, a question rises up from the center of my being: "Can you remain standing in your pain and keep forgiving from your heart?" I am wounded, wounded by experiences of betrayal and abandonment, wounded by my own self-rejection, wounded too by my inability to reach out to those around me, whether near or far away, and take away their pain. But I am constantly tempted to escape it all—to hide away in complaints or accusations, to

become a victim of despair or a prophet of doom. My true call is to look the suffering Jesus in the eyes and not be crushed by his pain, but to receive it in my heart and let it bear the fruit of compassion. I know that the longer I live, the more suffering I will see and that the more suffering I see, the more sorrow I will be asked to live. But it is this deep human sorrow that unites my wounded heart with the heart of humanity. It is in this mystery of union in suffering that hope is hidden. The way of Jesus is the way into the heart of human suffering. It is the way Mary chose and many Marys continue to choose. Wars come and go, and come again. Oppressors come and go, and come again. My heart knows this even when I do whatever I can to resist the oppressor and struggle for peace. In the midst of it all, I have to keep choosing the ever-narrowing path, the path of sorrow, the path of hope. The sorrowful women of this world are my guides.

V

SIMON HELPS
JESUS CARRY
HIS CROSS

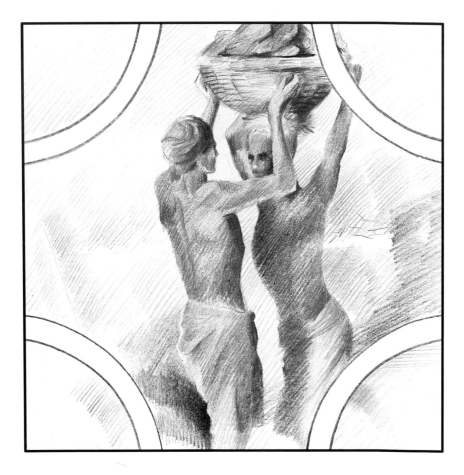

Two men are working together in Bangladesh to build their small huts. These huts are very simple, made of mud, bamboo, rocks, and jute sticks, but they are places where people can have a sense of home and live together under a protective roof. As I look at these two men carrying together their heavy load of rocks, I am struck by the harmony of their bodies. It seems almost as if they are dancing. Their heavy load seems to become a light burden, a basket of fruit.

As I think of the highly competitive society in which I live, in which land gets more expensive day by day and in which developers build rows of houses to be sold for half a million dollars each, I feel a certain envy toward these "dancers." Their houses will be simple. There may not be a cement or wooden floor; there may not be any tables, chairs, or dressers. But there will be a safe place for family and friends, and there will be a deep sense of having made something together that is precious and sacred.

Rich people have money. Poor people have time. We are always busy running from one place to the other, doing one thing after the other, keeping track of all the things that money can buy. But seldom do we feel that we are truly together. Among many poor people, however, I have seen the art of working, eating, playing, and praying together. I have seen broad smiles, and I have heard wild laughter and many words of thanks. There always seemed to be plenty of time and a deep

trust that even when there are few things to hold onto there are always many people to love.

When Jesus was carrying his cross to Golgotha, the soldiers came across a man from Cyrene, called Simon, and they enlisted him to carry the cross because it had become too heavy for Jesus alone. He was unable to carry it to the place of his execution and needed the help of a stranger to fulfill his mission. So much weakness, so much vulnerability. Jesus needs us to fulfill his mission. He needs people to carry the cross with him and for him. He came to us to show us the way to his Father's home. He came to offer us a new dwelling place, to give us a new sense of belonging, to point us to the true safety. But he cannot do it alone. The hard, painful work of salvation is a work in which God becomes dependent on human beings. Yes, God is full of power, glory, and majesty. But God chose to be among us as one of us — as a dependent human being. To his followers who wanted to defend him with their swords Jesus said: "Put your sword back. . . . Or do you think that I cannot appeal to my Father, who would promptly send more than twelve legions of angels to my defense? But then, how would the Scriptures be fulfilled that say this is the way it must be?" (Matt. 26:52–54). Jesus' way is the way of powerlessness, of dependence, of passion. He who became a child, dependent on the love and care of Mary and Joseph and so many others, completes his earthly journey in total dependency. He becomes a waiting God. He waits, wondering what others will do with him. Will he be betrayed or proclaimed? Executed in abandonment or followed? Will he be nailed to the cross with no followers near him or will someone help him to carry the cross? For Jesus to become the savior of the world, he needs people willing to carry the cross with him. Some do it

voluntarily; some have to be "enlisted"; but once they feel the weight of the wood, they discover that it is a light burden, an easy yoke that leads to the Father's home.

I feel within me a strong desire to live my life on my own. In fact, my society praises the self-made people who are in control of their destinies, set their own goals, fulfill their own aspirations, and build their own kingdoms. It is very hard for me to truly believe that spiritual maturity is a willingness to let others guide me and "lead me even where I would rather not go" (John 21:18). And still, every time I am willing to break out of my false need for self-sufficiency and dare to ask for help, a new community emerges—a fellowship of the weak—strong in the trust that together we can be a people of hope for a broken world. Simon of Cyrene discovered a new communion. Everyone whom I allow to touch me in my weakness and help me to be faithful to my journey to God's home will come to realize that he or she has a gift to offer that may have remained hidden for a very long time. To receive help, support, guidance, affection, and care may well be a greater call than that of giving all these things because in receiving I reveal the gift to the givers and a new life together can begin. These two men of Bangladesh are not just working together. They are celebrating their shared humanity and so preparing a new home. That is Jesus' call to all people, a call that often comes to us through the poor.

VI

JESUS MEETS
VERONICA

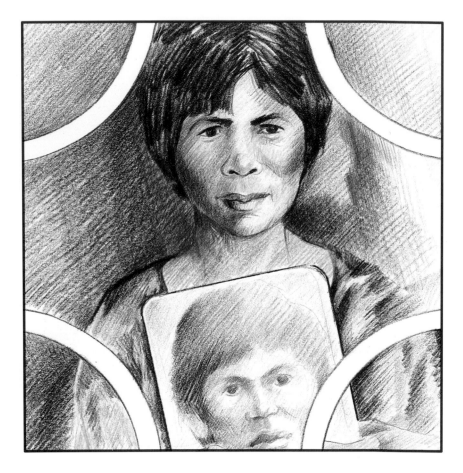

B ring him home!" That is the cry of the Filipino woman who holds in her hands a photograph of her "disappeared" husband. Her eyes plead for compassion. Her lips express deep grief. Her face is full of expectation. She says, "Do you see my pain, my anguish? . . . The one I most love has disappeared. There is no second of my days or nights that is not filled with the anguish created by his sudden going. Where is he? In prison? Being tortured? Dead or alive? Please answer me! If he is dead, tell me where his grave is so that I can go and weep there. You people of the world! Listen to me! Look at me! Please answer!"

This Filipino woman represents thousands of anguished women whose husbands or sons suddenly disappeared and were never seen again. They live in Argentina and Guatemala, but also in the United States and Canada. They reveal to us the deepest wounds of humanity, the cruelly sundered bonds between humans, parents and children, husbands and wives, brothers and sisters. The catastrophic displacement of large groups of people, the overcrowded refugee camps, the wars raging between nations and parts of nations have dislocated more people than ever before in human history. We can indeed speak of a dislocated humanity.

Veronica had been with Jesus as he taught, cured the sick, and announced the kingdom. Jesus had become the center of her life. Now she saw him cruelly pulled away from her. She was overwhelmed with grief and

agony and wanted to do something. When she saw him coming close, she broke through the crowds and covered his sweat- and blood-stained face with her veil. Jesus responded to this act of love and mourning by leaving there the image of his face—the face of a dislocated humanity. Jesus' face is the face of every man and woman who suffers separation, segregation, and displacement. Veronica is the woman of sorrow; a sorrow that pierces the heart with immense pain; a sorrow that is being suffered all over the world by women of countless nationalities, races, and social conditions. The agonizing question: "Why have they taken my child, my husband, my friend away?" can be heard as a scream resounding in all the corners of our world.

Can I hear that cry also in my own innermost self? The walls of my room are covered with photographs of friends and family and with icons of Jesus, Mary, and the saints, but deep in my heart there is unspeakable pain—the pain caused by absence. The one I most want to be with is not with me, and, even if we could be together, we would not be able to reach each other's deepest need. Veronica's pain is my pain too. I so crave for communion, for a deep sense of belonging, for intimacy, but wherever I go, whomever I meet, there is ever and again that experience of absence, disconnectedness, and isolation. It seems as if a sword is piercing all communion and adding pain to every intimacy. The pictures on my wall reveal my thirst for communion, but as I gaze at them with great love, I feel an immense pain rising up in me: "Why can't I speak with him? Why will she never write? Why did they die before we were ever reconciled? Why can't we feel safe with each other?" And as I light a candle in front of my icon of Jesus and look into the eternity of his eyes, I say, "When, when, Lord,

will you come and fulfill the deepest longing of my heart?" The thirst for communion is evoked every time I look at Veronica's veil with the face of Christ on it and the faces of all whom I love . . . and the pain deepens as I grow older.

I know that I have to lose my life to find it—to let go of my pictures and to meet the real person—to die to my sentimental memories and trust that a new communion will emerge which is beyond all my imagining. But how can I trust in a new life when I see the blood- and sweat-stained life of Jesus and of all those who suffer in prisons, refugee camps, and torture chambers? Jesus looks at me and seals my heart with the imprint of his face. I will always keep searching, always waiting, always hoping. His suffering face does not allow me to despair. My sorrow is a hunger, my loneliness a thirst. As we meet, we know that the love that causes us pain is the seed of a life where pain cannot abide.

VII

JESUS FALLS
FOR THE SECOND
TIME

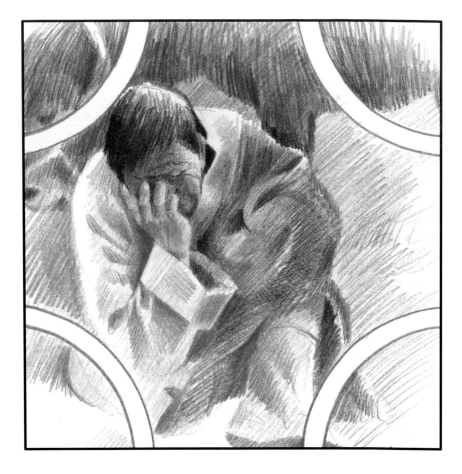

This poor farmer in Brazil is completely exhausted. He has worked on the land for hours, days, weeks, and months to earn enough for himself and his family to have a decent meal. But after many years of hard labor nothing has improved. The crops are poor because of the exhausted soil he has to work. He cannot compete with those who can afford modern agricultural techniques to improve the land. The money he receives for his produce is so little that he cannot even pay off the debt he has incurred to keep his wife and children alive. And every year the situation gets worse. He faces the possibility of having to leave his little farm and join the millions of poor in the slums around the large cities. There was a time when he dreamed of having paid off his debts and being able to give his children an education, and maybe even to earn enough money to buy a piece of more productive land. But all these dreams are scattered now. He and his horse have become old and very tired. In every part of his body he feels the pain of hard labor, and, as he closes his eyes and holds his hand before his face, he sees nothing but an empty future. His heart becomes very dark. He wonders why he goes on living when all his efforts come to nothing. He sees himself as a failure, and he blames himself for not being the husband, the father, and the friend he had hoped to be.

This desperate farmer is only one out of the millions of people who have become victims of great economic forces over which they have no control. They find them-

selves unable to continue the work of their parents and grandparents, and they have little or no understanding of the national and international movements that have taken them from a life of simple farming to a life of poverty and fear and from a life in poverty and fear to a life of misery and destitution.

When Jesus falls for the second time, it is not now because the cross he carries is too heavy, but because in his whole body he experiences complete exhaustion. He is totally spent. The years of work in his home town, the time of preaching, of going from town to town with his disciples followed by large crowds, have all taken a heavy physical toll. And more recently, he has had to bear the increasing resistance to his call to conversion: personal threats on his life, the defection of many followers, the betrayal of Judas and the denial of Peter, the scourging, the ridicule, the complete lack of understanding on the part of Herod and Pilate, and the screaming of hostile crowds. It is too much for any one person to carry. And so, he stumbles and falls. Where are his dreams of starting a new age of love and forgiveness? At first it seemed that many shared his vision. Now he is completely alone, wondering why he no longer hears that voice that spoke to him at the Jordan River and on Mount Tabor. Did he make a mistake, or was he the victim of powers he could not control?

Jesus knows so well that moment in which we no longer want to go on, in which we want to give up and let despair take its destructive course. It is not only in the poverty-stricken parts of Brazil and other developing countries that people suffer under these emotions. The rich and prosperous are as much tempted to despair as are the poor and destitute. From my own struggles I

know what the Brazilian farmer feels in his inner soul. I, too, even when my economic future seems secure, can suddenly become subject to very disturbing feelings of guilt and shame, fear and despair. And as I look around me into the eyes of the people who have lived a long life and worked hard, I often see that same question: "Is my life worth anything?" There can arise in our hearts a deep fatigue that makes it seem impossible to go on. Everything looks like one big failure. All our efforts seem to have come to nothing. Dreams are scattered, hopes are dashed, aspirations are ripped away. Depression takes over, and nothing seems to matter any more.

Jesus suffered this with us as he fell. He calls us now to trust that both his and our falling are a true part of the way of the cross. Maybe all that we can do when we fall is to remember that Jesus fell and is falling now with us. That remembrance may become the first inkling that there is hope. And that hope may bind together in a new way the world of the Brazilian farmer and our world, and show us the direction to a more just and loving society.

VIII

JESUS MEETS
THE WOMEN
OF JERUSALEM

MATIGNON HIGH SCHOOL LIBRARY

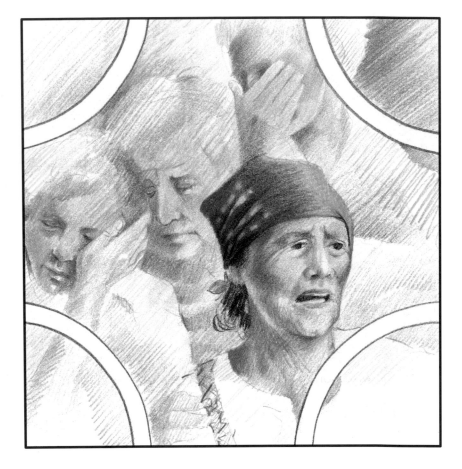

These Nicaraguan women weep over the destruction of their people, their land, and their homes. Their children, whom they nursed and brought up with tenderness and affection, suddenly lie dead before them. Their husbands, with whom they shared life's hardness and beauty, are suddenly taken away to unknown destinations. Their land is ruined, their crops burned, their houses bombed. And so they weep. Their tears are tears that well up from their innermost being. There are no words, no explanations, no arguments, no meaningful reflections. War, violence, murder, and destruction need tears, many tears. The questions, "Why? By whom? For what purpose?" have no answers.

The world would be better with more such tears and fewer answers. They well up from a place beyond bitterness, resentment, and vengefulness. They are shed as an offering of "useless" love, as an expression of solidarity, as a true act of nonviolence.

Our world does not mourn much, even when there are so many reasons to mourn. As wars explode; as people die from violence and starvation, natural disasters and technical failures; as works made by human hands with great skill and devotion are stolen, damaged, or destroyed; and as our planet becomes an increasingly threatened place in the universe, we begin to worry about solutions, but we seldom stop to mourn the loss of what was dear to us. But, if we have not first mourned our loss, can any solution we arrive at be a real gain?

As Jesus was led to his execution, women mourned and lamented for him. These women were accustomed to cry for condemned criminals and offer them sedative drinks. They were official mourners, and their mourning was considered a work of mercy. But Jesus says to them: "Do not weep for me; weep rather for yourselves and for your children" (Luke 23:28). Jesus points to the destruction of Jerusalem and to all the war and violence that will come upon humanity: "The days are surely coming, when people will say: 'Blessed are those who are barren, the wombs that have never borne children, the breasts that have never suckled'; then they will say to the mountains, 'Fall on us'; to the hills, 'Cover us.' For if this is what is done to the green wood, what will be done when the wood is dry?" (Luke 23:29–31).

If we want to mourn for Jesus, we have to mourn for the suffering humanity that Jesus came to heal. If we are truly sad because of the suffering and pain which he suffered, we will include in our sadness all of the men, women, and children who suffer in our present world. If we cry over the death of the innocent Holy One of Nazareth, our tears must be able to reach the millions of innocents who have suffered over the long history of the human race.

Weeping and mourning are considered by many people as signs of weakness. They say that crying will not help anybody. Only action is needed. And still, Jesus wept over Jerusalem; he wept also when he heard that his friend Lazarus had died. Our tears reveal to us the painful human condition of brokenness; they connect us deeply with the inevitability of human suffering; they offer the gentle context for compassionate action. If we cannot confess our own limitations, sin, and mortality, then our well-intended actions for the making of a better world

easily backfire on us and become expressions of an undirected anger and frustration. Our tears can lead us to the heart of Jesus who wept for our world. As we weep with him, we are led to his heart and discover there the most authentic response to our losses. The tears shed by the women of Nicaragua and the millions who mourn their dead throughout the world, can make our soil rich with the fruits of compassion, forgiveness, gentleness, and healing action. We, too, must weep and so become more and more humble people.

IX

JESUS FALLS
FOR THE THIRD
TIME

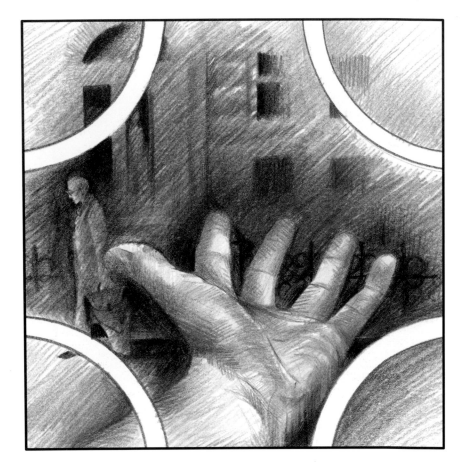

A man stumbles and falls to the ground. He is so weak and filled with pain that he cannot get back on his feet without help. As he lies there powerless, he reaches out and opens his hands, hoping that another hand will grasp his and help him to stand again. A hand waits for the touch of another hand. The human hand is so mysterious. It can create and destroy, caress and strike, make welcoming gestures and condemning signs; it can bless and curse, heal and wound, beg and give. A hand can become a threatening fist as well as a symbol of safety and protection. It can be most feared and most longed for.

One of the most life-giving images is that of human hands reaching out to each other, touching each other, interconnecting and merging into a sign of peace and reconciliation. In contrast, one of the most despairing images is that of a hand stretched open, waiting to be touched with care, while people walk heedlessly by. This is not only an image of the loneliness of the individual person, but of the loneliness of a divided humanity. The hand of the poor world reaches out to be touched by the hand of the rich world, but the preoccupations of the rich prevent them from seeing the poor, and humanity remains broken and fragmented.

When Jesus fell for the third time, he lived in his body all the loneliness of a despairing humanity. He could not get up again without help. But there was no one reaching out to him and offering him the support to stand

again. Instead, his open hands were struck with a lash, and cruel hands pulled him back to a standing position. Jesus, God-made-human, falls so that we can bend over to him and show him our love and compassion, but we are too busy with other things even to notice. God, whose hands molded the universe, gave shape to Adam and Eve, touched every suffering person with tender-ness,and who holds all things in love, became a human person with human hands asking for human hands. But those very hands were left open and pierced with nails.

Ever since I came to know God's hand—not as the powerful hand controlling the course of history, but as the powerless hand asking to be grasped by a caring human hand—I have been looking differently at my own hands. Gradually, I have come to see God's powerless hand reaching out to me from everywhere in the world, and, the clearer I see it, the closer these outstretched hands seem to be. The hands of the poor begging for food, the hands of the lonely calling for simple presence, the hands of the children asking to be lifted up and held, the hands of the sick hoping to be touched, the hands of the unskilled wanting to be trained—all these hands are the hands of the fallen Jesus waiting for others to come and give him their hand.

There is always in me the temptation to think about the begging hands of the people in Calcutta, Cairo, or New York, far, far away, and not to see the open hands reaching out right into my own living space. Every night I go to rest and look at my hands. And I have to ask them: "Did you reach out to one of the open hands around you and bring a little bit of peace, hope, courage, and confidence?" Somehow I sense that all human hands asking for help belong to the hands of our fallen humanity and that wherever we reach out and touch, we

participate in the healing of the whole human race.

Jesus falling and seeking help to get up again to fulfill his mission, opens up for us the possibility of touching God and all of humanity in every human hand and experiencing there the true grace of God's saving presence in our midst.

X

JESUS IS
STRIPPED

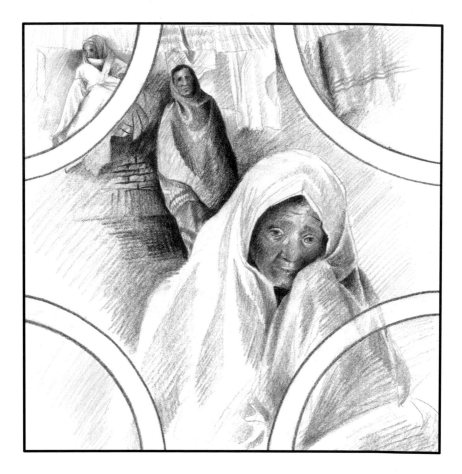

This woman in a hospital ward in Katmandu has nothing but a blanket to cover her aging body. Her long life of work in the fields and caring for her husband and children has come down to a naked, anonymous existence. Her life, once filled with joyful sounds and colorful movements, now has fallen silent. Where is the husband who honored her, and the children who gave her joy and pleasure? Where are the neighbors who came for her advice? Where the rivers with their sonorous rapids and the hills bedecked with greens and flowers in the spring? Everyone and everything has been stripped away from her. One day some strangers came to her village and brought her to the city hospital and locked the door of the psychiatric ward behind her. They called her mad. There was no one to defend her, no one to speak in her name, no one to protect her dignity. Her mind has become confused. Sometimes memories of long ago emerge, names from years past cross her lips, scenes of youth and adulthood appear, and no one responds.

Here is the true nakedness. All human dignity is gone, and she, who once was so lovely to see, now hides her nakedness under a blanket. Countless are the old men and women who live their stripped-down existences hidden away from the fast-moving world of our century. Their growing old has left them with nothing but their naked existence, completely dependent on the randomly bestowed favors or rejections of their milieu.

Jesus was stripped. The soldiers threw dice to decide which of them would have his garment (see John 19:24).

Nothing was left to him. He, the image of the unseen God, the first-born of all creation, in whom all things were created in heaven and on earth, everything visible and everything invisible, thrones, ruling forces, sovereignties, powers — he it was, being stripped of all power and dignity and exposed to the world in total vulnerability. Here the greatest mystery of all time was revealed to us: God chose to reveal the divine glory to us in humiliation. Where all beauty is gone, all eloquence silenced, all splendor taken away, and all admiration withdrawn, there it is that God has chosen to manifest unconditional love to us. "Many people were aghast at him — he was so brutally disfigured that he no longer looked like a man — so will many nations be astonished and kings will stay tight-lipped before him. . . . He had no charm to attract us, no beauty to win our hearts, he was despised, the lowest of men, a man of sorrows, familiar with suffering, one from whom, as it were, we averted our gaze, a despised man for whom we had no regard" (Isa. 52:14–15, 53:2–3).

Jesus bore our suffering. The stripped body of Jesus reveals to us the immense degradation that human beings suffer all through the world, at all places and in all times. Often I think of life as a journey to the mountaintop where I will see at last the full beauty of my surroundings and where I will experience myself in full possession of all my senses. But Jesus points in the other direction. Life is an increasing call to let go of desires, of success and accomplishment, to give up the need to be in control, to die to the illusion of greatness. The joy and peace that Jesus offers is hidden in the descending way of the cross. There lie hope, victory, and new life, but they are given to us where we are losing all. "Those who lose their life will gain it" (Luke 9:24).

I should not be afraid to lose, nor afraid for those who have lost much, if not all. Jesus was stripped so that we would dare to embrace our own poverty and the poverty of our humanity. In looking at our impoverished selves and the poverty of our fellow human beings, we come to discover the immense compassion that God shows to us. And there we will know how to give and forgive, how to care and to heal, how to offer help and create a community of love. In the solidarity of poverty, we find the way to grow closer to each other and joyfully to claim our common humanity.

XI

JESUS IS NAILED
TO THE CROSS

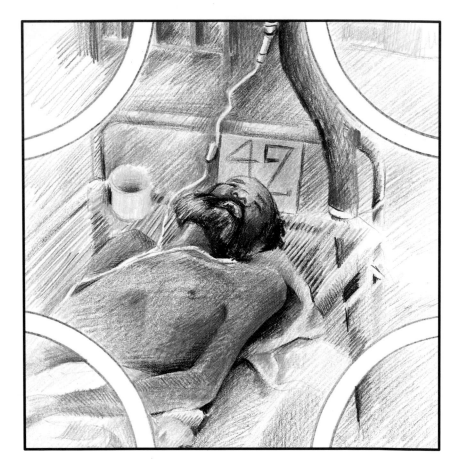

This Sudanese man is dying. He is alone. He has no name. He is one of the many dying in a large hospital. He is number 42. The intravenous tube is like his last lifeline. But it won't save him. All his strength is gone. His thin arms and emaciated shoulders reveal how far spent he is. Everyone around him knows that his last hours have come. He, too, knows it, but he is not afraid. Life has not been easy for him. It has been a life of poverty, many battles, and few victories. He was afraid of sickness and pain. But he is at peace with the knowledge that it soon will all be over.

People are dying every day, every hour, every minute. They die suddenly or slowly. They die on the streets of big cities or in comfortable homes. They die in isolation or surrounded by friends and family. They die in great pain or as if falling asleep. They die in anguish or in peace. But all of them die alone, facing the unknown. Dying is indeed a reality of daily life. And yet, the world generally goes about its business disowning this reality. Dying is often a hidden event, something to ignore or deny. The Sudanese man, however, expresses the truth of life. All of life comes to an end. Dying belongs to living.

Jesus was nailed to the cross, and for three hours he was dying. He died between two men. One of them said to the other: "We are paying for what we did. But this man has done nothing wrong" (Luke 23:41). Jesus lived

his dying completely for others. The total exhaustion of his body, the abandonment by his friends, and even of his God, all became the gift of self. And as he hung dying in complete powerlessness, nailed against the wood of a tree, there was no bitterness, no desire for revenge, no resentment. Nothing to cling to. All to give. "Unless a grain of wheat falls into the earth and dies, it remains only a single grain, but if it dies, it yields a rich harvest" (John 12:24). By being given away for others, his life became fruitful. Jesus, the completely innocent one, the one without sin, without guilt, without shame, died an excruciatingly painful death in order that death no longer would have to be ignored, but could become a gateway to life and the source of a new communion.

As we look at the dying Jesus, we see the dying world. Jesus, who on the cross drew all people to himself, died millions of deaths. He died not only the death of the rejected, the lonely, and the criminal, but also the death of the high and powerful, the famous and the popular. Most of all, he died the death of all the simple people who lived their ordinary lives and grew old and tired, and trusted that somehow their lives were not in vain.

We all must die. And we all will die alone. No one can make that final journey with us. We have to let go of what is most our own and trust that we did not live in vain. Somehow, dying is the greatest of all human moments because it is the moment in which we are asked to give everything,. The way we die has not only much to do with the way *we* have lived, but also with the way that *those who come after us* will live. Jesus' death reveals to us that we do not have to live pretending that death is not something that comes to all of us. As he hangs stretched out between heaven and earth, he asks us to look our mortality straight in the face and trust that

death does not have the last word. We can then look at the dying in our world and give them hope; we can hold their dying bodies in our arms and trust that mightier arms than ours will receive them and give them the peace and joy they always desire.

In dying, all of humanity is one. And it was into this dying humanity that God entered so as to give us hope.

XII

JESUS DIES
ON THE CROSS

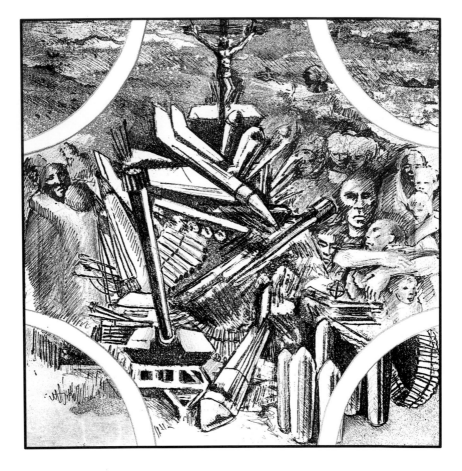

Death, destruction, and annihilation surround us on all sides. Much, if not most, of the earth's resources are used in the service of death. The war industries eat up huge amounts of the national income of many countries. The stockpile of conventional and nuclear weapons increases day by day, and whole economies have become dependent on the ever-increasing production of lethal materials. Many universities, research institutions, and think tanks receive their financial support from warmakers. Millions of people earn their daily living by turning out products which, if ever used, could only produce death.

But the power of death is much more subtle and pervasive than these explicitly brutal forces of destruction. Not only are there death forces visible in the violence within families and neighborhoods, they are also part of the ways in which people look for relaxation and entertainment. Many sports are tainted by a fascination with death. The possibility of serious injury and death creates an unusual excitement. People like to watch people who risk their very lives and are drawn into the darkness of the Russian roulette. Many forms of entertainment, such as movies, TV series, and novels, also exploit people's fascination with death. The world is, indeed, ruled by the powers of death, powers that want every human being to be in their service.

Jesus died. The powers of death crushed him. Not only the fear-ridden judgments of Pilate, the torture by

the Roman soldiers, and the cruel crucifixion, but also
the powers and principalities of this world. The world's
death powers destroyed him. But the death of Jesus is
the death of the Word "through whom all things came
into being," and "what has come into being in him was
life, life that was the light of people, and the light shines
in the darkness, and darkness could not overpower it"
(John 1:3–5).

Jesus was crushed by the powers of death, but his
death removed death's sting. To those who believe in
him he gave the power to become children of God, that
is, to participate in the life where death can no longer
reach. By his death, Jesus was victorious over all the
powers of death. The darkness in our hearts that makes
us surrender to the power of death, the darkness in our
society that makes us victims of violence, war, and
destruction, has been dispelled by the light that shines
forth from the One who gave his life as a complete gift to
the God of life. Paul says: "Our Savior Christ . . . has
abolished death and he has brought to light immortality
and life through the Gospel" (2 Tim. 1:10).

It is hard to affirm life in the face of the rampant
powers of death. Every time we open a newspaper with
all its stories of war, murder, kidnapping, torture,
battering, and countless other tragedies that lead to
sickness and death, we are faced with the temptation to
believe that, after all, death is victorious. And still, time
and time again the death of Jesus, the Holy One, calls
us to choose for life. The great challenge of the Christian
life is to say "Yes" to life even in the smallest and, seem-
ingly, unimportant details. Every moment there is a
choice to be made: the choice for or against life. Do I
choose to think about a person in a forgiving or in an
accusing way? Do I choose to speak a word of accept-

ance or a word of rejection? Do I choose to reach out or to hold back, to share or to hoard, to yield or to cling, to hurt or to heal? Even the deeper emotions of our heart are subject to such choices. I can choose to be resentful or grateful, despairing or hopeful, sad or glad, angry or peaceful. Many of these emotions can come to us as waves over which we have no control. Still . . . there is a place in us where we can choose a direction and stop the forces of death from pulling us deeper and deeper into the pit of darkness.

We often live as if the great powers of darkness that can bring us to the verge of a nuclear holocaust are completely separated from what we think and feel in our hearts. That separation is an illusion. The tiniest inner fascination with death and the most horrendous forms of human destruction are intimately connected. Jesus knew about this connection and, when his heart was pierced, it was the heart that embraces our most hidden thoughts and our most far-reaching actions. The death of Jesus overcame all the forces of death and "set free all those who had been held in slavery all their lives by the fear of death" (Heb. 2:15).

XIII

JESUS IS TAKEN
FROM THE CROSS

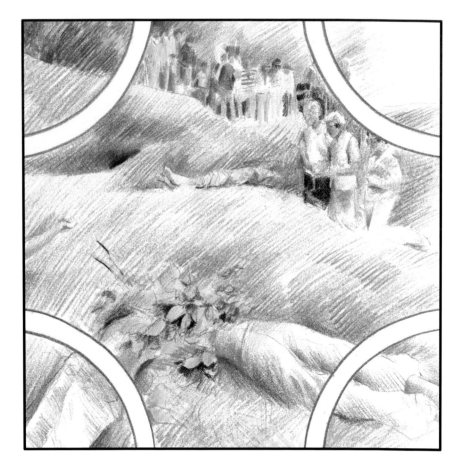

In December 1980, Ita Ford, Maura Clarke, Jean Donovan, and Dorothy Kazel were brutally murdered on the road between the airport and San Salvador, the capital city of El Salvador. They had been stopped by Salvadoran security forces as they returned to their home after a short stay outside of the country. They were raped, tortured, and killed and their bodies thrown into a common grave dug in a cow pasture. What was their crime? They had cared for the poor of El Salvador. They had tried to bring food and medicine to the people who had been driven from their homes and villages and were trying to survive in isolated mountain areas. These four faithful, hardworking churchwomen had no other desire than to alleviate some of the immense suffering of their oppressed neighbors and to show them, in the midst of hatred and violence, that people can truly love one another.

But their care and concern had fired the rage of the oppressors and had put their names on the death list. Their existence could no longer be tolerated; they had to be annihilated, eradicated from the face of the earth. Their simple presence had become unbearable for the enemies of life. The hatred was blatant and undisguised. They must be killed immediately.

Shortly after they had been assassinated and their bodies covered with dirt, they were found. Their friends and the poor people of the area stood there in unspeakable sorrow, gazing in anguish at the slaughter of the innocent women. An immense grief pierced their hearts,

and grief screamed out through all the world: "How long, how long, O Lord, before justice will reign?"

After Pilate had been assured of Jesus' death, he granted the body to Joseph of Arimathea, a prominent member of the Council "who himself had lived in the hope of seeing the Kingdom of God" (Mark 15:43). Joseph "bought a shroud, took Jesus down from the cross, and wrapped him in the shroud" (Mark 15:46). Mary, the mother of Jesus, was there. Long ago, when she had let old Simeon hold her child in his arms, she had heard his words: "A sword will pierce your soul" (Luke 2:35). Now, as she received the body of Jesus in her arms, these words were being fulfilled. Jesus had suffered and died, but the sorrow of her who had loved him as mother now brought forth a pain such as had never been suffered before by any human being. Mary's sorrow was as deep as her love. She who had embraced the Son of God with her love, now embraced the whole of humanity with her sorrow. She whose heart had been so pure that it could be a fitting abode for the Savior of the World, was called now to carry all human suffering in that heart and so become mother of all. Mary stood beneath the cross; Mary received the body of Jesus and held him in her immense solitude. The intimate union between love and sorrow that was formed as she held her son in her arms, would continue to exist in all those who chose to live close to the heart of God.

To love truly is to be willing to embrace sorrow. To love God with all your heart, all your mind, and all your strength is to expose your heart to the greatest sorrow a human being can know. Love for Jesus made the four American churchwomen carry in their hearts the sorrow of the poor of the world, especially those in El Salvador.

Their deaths, in turn, caused an immense sorrow in the hearts and minds of their brothers and sisters. The life of a Christian is a life of love for Jesus. "Do you love me?" That is the question he asks us three times. And when we say: "Yes Lord you know I love you," he says: "You will be taken where you would rather not go" (see John 21:15–18). There is never love without sorrow, never commitment without pain, never involvement without loss, never giving without suffering, never a "Yes" to life without many deaths to die. Whenever we seek to avoid sorrow, we become unable to love. Whenever we choose to love, there will be many tears. When silence fell around the cross and all was accomplished, Mary's sorrow reached out to all the ends of the earth. But all those who come to know that sorrow in their own hearts will come to know it as the mantle of God's love and cherish it as the hidden mystery of life.

XIV

JESUS IS LAID
INTO THE GRAVE

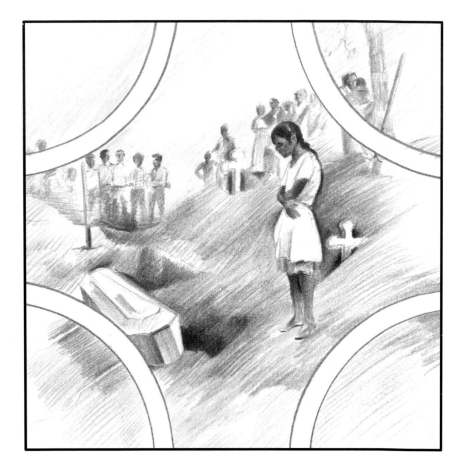

young Salvadoran woman stands in front of the casket that holds the body of her cruelly executed husband. She stands alone near the grave into which the casket will be lowered. Her eyes are closed, her arms folded across her body. She stands there barefoot, poor, empty . . . but very still. A deep quiet surrounds her. No shouts of grief, no cries of protest, no angry voices. It seems as if this young widow is enveloped in a cloud of peace. All is over, all is quiet, all is well. Everything has been taken away from her, but the powers of greed and violence that robbed her of her lover can't reach that deep solitude of her heart. In the background stand her friends and neighbors. They form a protective circle around her. They honor and respect her solitude. Some are silent; some whisper words of consolation; some try to explain to each other what happened; some embrace and cry. But the woman stands there alone. She understands something that the powers of death cannot understand. There are a trust and confidence in her that are vastly more powerful than the weapons that killed her husband. The solitude of the living and the solitude of the dead greet each other.

Joseph of Arimathea placed the body of Jesus "in a tomb which was hewn in stone and which had never held a body. . . . Meanwhile, the women who had come from Galilee with Jesus were following behind. They took note of the tomb and how the body had been laid. Then they

returned and prepared spices and ointments. And on the Sabbath day they rested . . ." (Luke 23:53–56).

There was deep rest around the grave of Jesus. On the seventh day, when the work of creation was completed, God rested. "God blessed the seventh day and made it holy, because on that day he rested after all his work of creating" (Gen. 2:3). On the seventh day of the week of our redemption, when Jesus had fulfilled all he was sent by his Father to do, he rested in the tomb, and the women whose hearts were broken with grief rested with him. Of all the days in history, Holy Saturday—the Saturday during which the body of Jesus lay in the tomb in silence and darkness behind the large stone that was rolled against its entrance (Mark 15:46)—is the day of God's solitude. It is the day on which the whole creation waits in deep inner rest. It is the day on which no words are spoken, no proclamations made. The Word of God through whom all had been made lay buried in the darkness of the earth. This Holy Saturday is the most quiet of all days. Its quiet connects the first covenant with the second, the people of Israel with the not-yet-knowing world, the Temple with the new worship in the Spirit, the sacrifices of blood with the sacrifice of bread and wine, the Law with the Gospel. This divine silence is the most fruitful silence that the world has ever known. From this silence, the Word will be spoken again and make all things new.

We have much to learn about God's resting in silence and solitude. The Salvadoran woman at her husband's graveside knew something about it. She participated in it and trusted that it would bear fruit in her. Even though we are surrounded by the racket of our world's pre-occupations, we, like this woman, can rest in God's silence and solitude and let it bear fruit in us. It is a rest

that has nothing to do with not being busy, although that might be a sign of it. The rest of God is a deep rest of the heart that can endure even as we are surrounded by the forces of death. It is the rest that offers us the hope that our hidden, often invisible existence will become fruitful even though we cannot say how and when. It is the rest of faith that allows us to live on with a peaceful and joyful heart even when things are not getting better, even when painful situations are not resolved, even when revolutions and wars continue to disrupt the rhythm of our daily lives. This divine rest is known by all those who live their lives in the Spirit of Jesus. Their lives are not characterized by quietness, passivity, or resignation. On the contrary, they are marked by creative action for justice and peace. But that action comes forth from the rest of God in their hearts and is, therefore, free from obsession and compulsion, and rich in confidence and trust.

Whatever we do or do not do in our lives, we need always to remain connected with the rest of the Holy Saturday when Jesus lay buried in the tomb and the whole of creation waited for all things to be made new.

XV

JESUS RISES
FROM THE DEAD

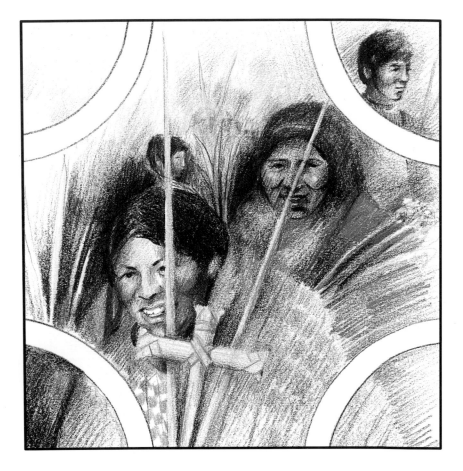

These Indian people of South America radiate deep inner joy and peace. The straw crosses they have woven symbolize their hardships and struggles. The long palm leaves that they flourish manifest their sense of victory and triumph. Yes, there is sadness, but gladness too. Yes, there is grief, but joy as well. Yes, there is fear, but also love. Yes, there is hard work, but celebration follows. And, yes, there is death, but also resurrection.

The smiles breaking through the weathered faces of the women and men walking in procession speak of a deep faith in the resurrection. It is a faith that not only trusts that life is stronger than death, but also offers a foretaste of the joy that will last forever. The eyes of the poor can suddenly become luminous with hope and open up horizons far beyond the limited vision of a self-preoccupied humanity. The poor of the world carry in their hearts a resurrection faith, a faith that knows that all that is created is created not to be wasted, but to be transformed into a new heaven and a new earth. The beautiful smiles on the faces of the poor of Bolivia, Peru, Nepal, Pakistan, Burundi, the Sudan, and all over the planet, offer glimpses of the reality of the resurrection. These smiles come from the depths of hearts that know of a love that is real and everlasting.

On that morning of the first day of the week, Mary of Magdala, and Mary the mother of James and Salome found the tomb empty and heard a young man in a

white robe say: "He is not here." Two of the disciples, Peter and John, entered the tomb and saw the linen cloths lying on the ground and also the cloth that had been over Jesus' head. Mary of Magdala heard him call her by name, and Cleopas and his friend recognized him at Emmaus in the breaking of the bread. In the evening of that same day, he came and stood among his disciples, saying, "Peace be with you," and showed them his hands and his side.

As these things took place, new words broke out of the silence of Holy Saturday and touched the hearts and the minds of the men and women who had known and loved Jesus. These words were: "He has risen, risen indeed." They were not shouted from the rooftops or carried around the city on big placards. They were whispered from ear to ear as an intimate message that could be truly heard and understood only by a heart that had been yearning for the coming of the kingdom and had recognized its first signs in the words and deeds of the man from Nazareth.

All is different and all is the same for those who say "Yes" to the news that is whispered through the ages from one end of the world to the other. Trees are still trees, rivers are still rivers, mountains are still mountains, and people in their hearts are still able to choose between love and fear. But all that has been lifted up in the risen body of Jesus and placed at the right hand of God. The prodigal child is placed in the loving embrace of the Father; the little child is put in its mother's arms; the true heir has been given the best robe and a precious ring, and brothers and sisters invited to the same table. All is the same, and all is made new. As we live our lives with a resurrection faith, our burdens become light burdens and our yokes easy yokes because we have

found rest in the gentle and humble heart of Jesus that belongs for all eternity to God.

It is now time to speak again, quietly but confidently. New words emerge from the silence. Good news is brought to the poor, liberty to the captives, sight to the blind, freedom to the oppressed, and the favor of the Lord is proclaimed.

And so the smile of God and the smile of God's people reach each other and become one in the undying light that shines in the darkness.

CONCLUDING PRAYER

Dear Jesus,

You once were condemned; you are still being condemned. You once carried your cross; you are still carrying your cross. You once died; you are dying still. You once rose from the dead; you are still rising from the dead.

I look at you, and you open my eyes to the ways in which your passion, death, and resurrection are happening among us every day. But within me there is a deep fear of looking at my own world. You say to me: "Do not be afraid to look, to touch, to heal, to comfort, and to console." I listen to your voice, and, as I enter more deeply into the painful, but also hope-filled, lives of my fellow human beings, I know that I enter more deeply into your heart.

My fears, dear Lord, of opening my eyes to my suffering world are deeply rooted in my own anxious heart. I am not sure that I, myself, am truly loved and safely held, and so I keep my distance from other people's fear-filled lives. But again you say: "Do not be afraid to let me look at your wounded heart, to embrace you, to heal you, to comfort and console you . . . because I love you with a love that knows no bounds and poses no conditions."

Thank you, Lord, for speaking to me. I do so desire to let you heal my wounded heart and, from there, to reach out to others close by and far away.

I know, Lord, that you are gentle and humble of heart and that you call out: "Come to me, you who labor and are overburdened, and I will give you rest."

As your passion, death, and resurrection continue in history, give me the hope, the courage, and the confidence to let your heart unite my heart with the hearts of all your suffering people, and so become for us the divine source of new life.

Amen.